HOW TO PAINT
STILL LIFE
WITH
ACRYLICS

Macdonald

CONTENTS

HOW TO USE THIS BOOK

Here are step-by-step demonstrations of a range of subjects in different media, designed to illustrate different ways of painting and drawing. To get the most out of these exercises, study each one first and then either re-paint or re-draw it yourself, or apply the techniques to a subject or scene of your choice.

Copying. Don't be concerned about copying the exercises — many famous artists have borrowed ideas and painting techniques and have used them to develop their own individual style. Copying the exercises will make learning the techniques easier as you won't have to worry about finding a subject, composition or design.

Stay loose. Attack each painting or drawing vigorously and don't worry about making mistakes – the more you practise and experiment, the sooner you will see a dramatic improvement in your painting.

Experiment. Attack the subject boldly, taking risks with lines, colour, shapes and values will prevent your work looking tight and overworked. Apply paint freely and don't hold your brush too near the point or your brushwork will look tentative. You only need to hold the brush near the bristles when you are working on details. This also applies to drawing tools such as pencils or pastels. Start loosely, saving the detailed work for the finishing touches.

Keep it simple. Select simple subjects and compositions to start with. Restrict the number of colours you use and avoid overworking them. If you follow these simple rules you will soon produce surprisingly good paintings and then you can really start to experiment with more ambitious compositions and colour schemes and develop your own unique painting style.
Happy painting!

A MACDONALD BOOK

© Quintet Publishing Ltd 1986

First published in Great Britain in 1986
by Macdonald & Co (Publishers) Ltd
London & Sydney

A member of BPCC plc

Monahan, Patricia
How to paint still life with acrylics —
Macdonald Academy of Art
1. Polymer painting —
Technique I. Title
751.42'6 ND1535

ISBN 0 356 12474 6

This book was designed and produced by
Quintet Publishing Limited
6 Blundell Street, London N7

Typeset in Great Britain by
Facsimile Graphics Limited, Essex
Colour origination in Hong Kong by
Hong Kong Graphic Arts Limited, Hong Kong
Printed in Hong Kong by Leefung-Asco
Printers Limited

Macdonald & Co (Publishers) Ltd
Greater London House
Hampstead Road
London NW1 7QX

The term acrylic is used rather loosely to describe any pigment bound in a synthetic resin, whether the binder is acrylic or polyvinyl acetate. Acrylic paints have been around for about sixty years but while some important artists have adopted them as their medium of preference, they are still regarded with suspicion by the majority of amateur painters and many professionals who consider them as, at best, a poor substitute for oil paint. While acrylics share many of the characteristics of more traditional mediums such as oil, tempera and watercolour, they come into their own when they are exploited as a medium in their own right. However, a useful way of getting to know acrylic paint is to do projects in which you use it to mimic the qualities of other media.

Acrylic paint is water soluble and is generally available in two qualities, 'standard' formula has a buttery consistency rather like oil paint and 'flow' formula which is more fluid and is ideal for the staining techniques popular with many artists. Much of the excitement of acrylic paint comes from the many mediums which can be mixed with the paint to change the way it handles. Gloss and matt mediums alter the appearance of the dry paint, and gel mediums make the paint more fluid without changing its body and are excellent for glazing and thin washes. Texture paste allows the artist to build up thick impastos which hold the mark of the brush or knife. One of the characteristics of acrylic is the speed with which it dries, this is often an advantage but in cases where the artist wishes to increase the drying time mediums known as retarders can be added to the paint.

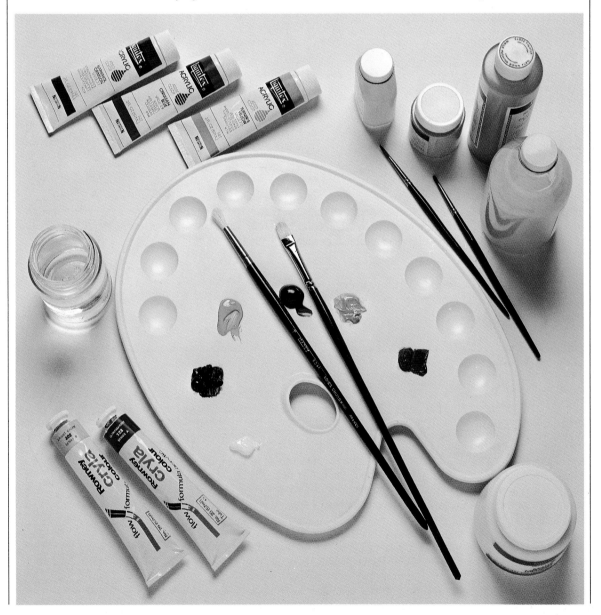

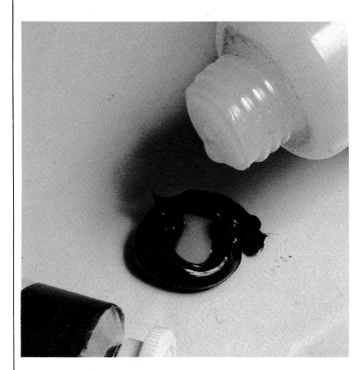

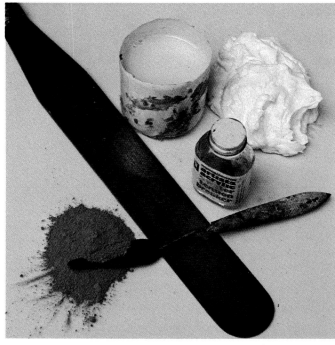

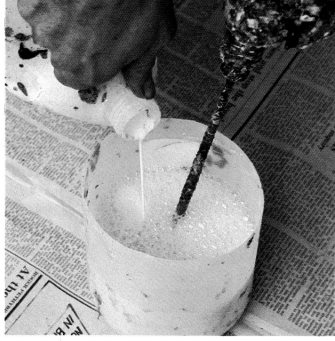

MATERIALS

The equipment for painting with acrylics is much the same as that used for oil painting and for watercolour. The paint is watersoluble so you will need plenty of water in suitable containers.

A wide variety of supports can be used: canvas, hardboard, card, paper, in fact, almost any smooth surface, even walls. Acrylic was actually first developed as a paint for exterior murals. Acrylic can be used directly onto most supports providing they are clean, smooth and free of grease. An acrylic primer provides a very pleasant ground to work on

and the paint will dry to a slight gloss, whilst that applied to an unprimed surface will dry to a matt finish. One very important point to remember is that oil primed canvases or supports cannot be used for acrylic, but acrylic grounds are excellent for receiving oil paint.

Any brush can be used, the ones you select will depend on the way in which you intend to use the paint. If you prefer thinly diluted paint used in a washy way which resembles pure watercolour, you will select soft fibred brushes such as squirrel, sable or one of the synthetic variety. If you wish to build up a thick, textured paint surface you will probably opt for a stiff bristle brush such as hog, or one of the

Mixing tube paint with medium. Squeeze sufficient paint onto a palette and add a drop of the appropriate medium (**top left**). *The paint is then blended with the medium using a stiff brush or a palette knife* (**above left**). *Large quantities of acrylic paint can be made by mixing raw acrylic medium, gel and powdered pigment* (**top**). *To make the gel, pour liquid acrylic medium into a large container and slowly add a thickening agent* (**above**).

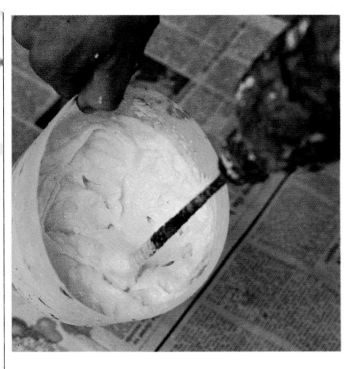

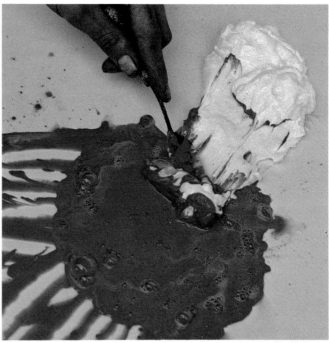

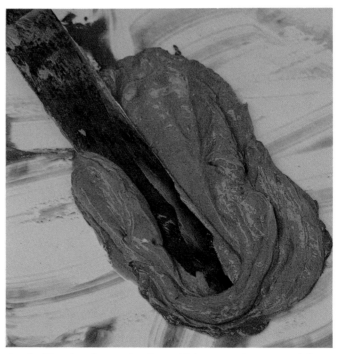

*Stir the mixture vigorously as it begins to gel (**top left**) and then let it stand for 8–12 hours. Place the powdered pigment on the palette, pour on the liquid acrylic medium and mix them together with a knife (**top right**). Add a few drops of water and then mix in the gel (**above left**). The paint should have a fairly thick buttery consistency (**above right**), but this can be thinned with water to suit your requirements.*

firmer synthetics. Palette knife and painting knife can be used very effectively with acrylic, especially if texture paste is added to the paint.

Palettes are a bit of a problem, acrylic paint dries very quickly and unless you are rigorous about cleaning up after each session you will find that you ruin your wooden palettes. Plastic or ceramic palettes are very useful, but a cheaper one can be made from a piece of formica or even glass.

You must be assiduous about cleaning your brushes, knives, and palettes at the end of every session. And don't forget to replace the caps of your tubes of paint. If you neglect to do so you will find yourself the owner of rock hard and unusable

brushes and paints which cannot be removed from their tube. If you put out too much paint on your palette you can keep it moist by spraying it with water and covering it with foil or cling film, anything which will retain moisture.

ABSTRACTING STILL LIFES

Acrylic is a versatile medium which is well-suited to the needs of the beginner and the more experienced artist alike. In fact those of you who are just starting out on your painting careers may well have more success with it than those who have been painting for years for you will approach it without prejudice whereas the old hands will compare it to other media rather than accepting it as a medium in its own right. Among its advantages are its excellent covering qualities and the good range of strong opaque colours. This is particularly well illustrated by the painting below where a vibrant yellow has been overlaid by a bright cadmium red to create a singing colour combination. Its opacity means that mistakes are easily corrected by overpainting — if a mistake is made allow the paint to dry before making the adjustment but because of its rapid drying time you will not have to wait long. In this respect it contrasts with watercolour in which the colours are transparent, making the correction or camouflaging of mistakes far more difficult. However, the speed with which acrylic paint dries means that you have to be very decisive. Keep a water spray near to hand so that your paint doesn't dry on the palette and if you have to leave the studio for a while spray the palette and cover it with cling film to retain the moisture and prevent drying. You can slow the drying process by adding retarder to your paint.

Recently new palettes designed for use with acrylic paint have come onto the market. These consist of a plastic tray covered with a moisture retaining material. Over this you lay a sheet of special paper which is discarded and replaced by a new one when you have finished the painting. The paints on the palette are kept moist by the water which passes by osmosis from the water-reservoir in the base of the tray. It sounds complicated but the palettes are fairly cheap and very effective.

Acrylic paint can be used to create thin washes, glazes or thick impastos. The paintings illustrated here are by one artist. In this series he was studying the underlying abstract qualities of a series of still life groups. The objects act as the jumping-off point for the composition rather than the true subject of the painting. Because the artist is no longer conerned with the surface reality of the object and with establishing its place in space, he can concentrate on the decorative qualities of the forms, and with the balance and tensions between the different shapes. Colour too comes into its own. All colour elicits an emotional response and freed of the need to recreate the visible world the artist can exploit these aspects of colour. The texture of the paint also assumes new significance.

Look at these paintings and then prepare a still life group. Decide what aspect of the subject appeals to you most — it may be the colour or the shapes, for example. If shape and line is your main concern you

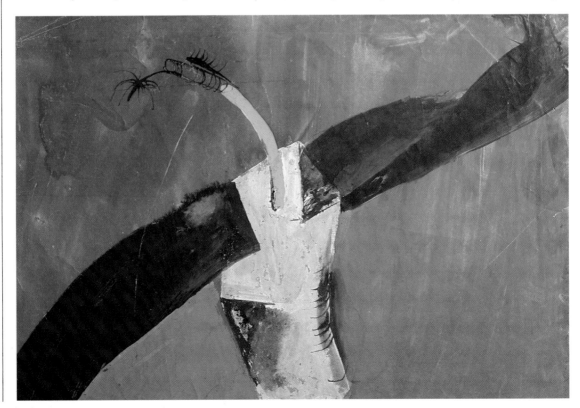

could, perhaps make a drawing of the negative spaces, the spaces between the objects and make this the basis of your abstract design. If colour relationships interest you, analyze the colours within the group. Then simplify, reduce or exaggerate the colours in order to create a pleasing design. In all painting, but in abstract painting in particular, what you leave out is as important as what you include.

The paintings here are all loosely based on still life arrangements but though the objects are recognizable, considerable licence has been taken with the colour and the composition. Far more attention has been paid to the graphic content and abstract shapes of the arrangements than to making a finished realistic painting. In the painting **(opposite)** *for example, a dark slash divides the painting into two triangles of vibrant red colour. The small streak of green in the centre is rendered more effective because it is surrounded by its complementary colour, red.*

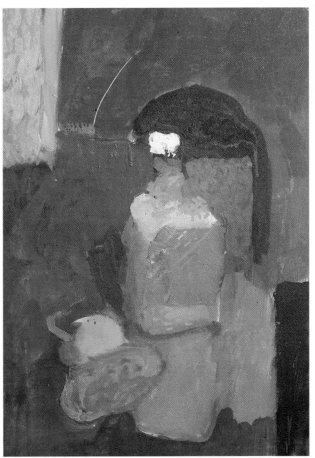

In the painting **(left)** *the subject is a still life with bread and fruit on a table and a chair in the background. The artist has simplified the image by selecting the elements he wishes to retain and rejecting others. If you study the image closely you can see the way he has built up the image in layers of colour, the opaque underpainting shimmering through the misty veils of colour which overlay and modify it, creating an image which is familiar yet full of ambiguities.*

For the image **(below)** *the artist has used a much more limited palette — a combination of ochres and broken greys. Again the painting is essentially an exercise in colour and composition yet the images have the insubstantial familiarity of dreams.*

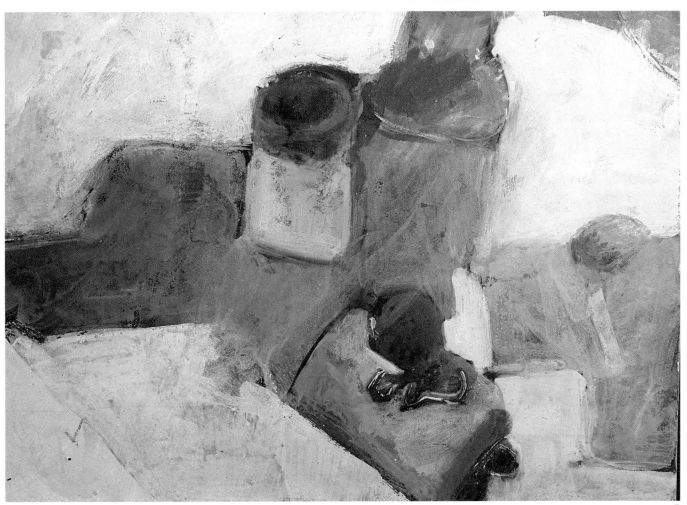

EXPLOITING CONTOURS

In this painting the artist has taken a familiar and simple still-life arrangement. He has produced an accurate drawing but he is not concerned with the realistic representation of what is there. The subject is merely the starting point for the composition. He was looking for the linear qualities in the subject. The edges have been treated not just as transitional areas between one object and the other but as important shapes in themselves. In this he is mirroring the practices of the Fauve masters, Henri Matisse (1869–1954) and George Rouault (1871–1958), who used emphatic outlines. And like Rouault his glowing colours have the quality of stained glass. A painting has been given the quality of an abstract work.

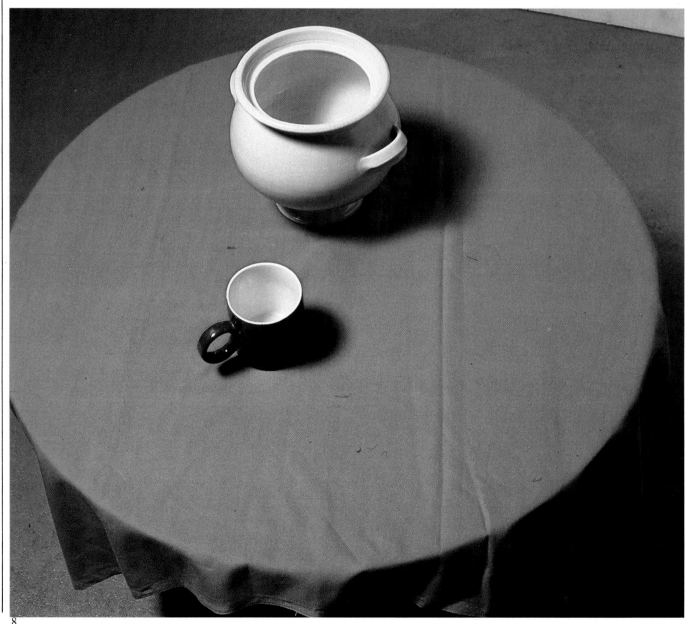

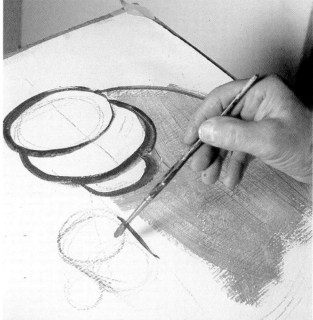

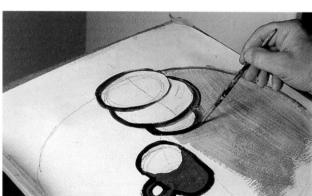

The artist assembles a simple group of objects with strong, distinct shapes **(opposite, bottom)**. Using charcoal he sketches the general outlines of the composition on a large piece of paper **(opposite, top)**. Using acrylic paint he boldly puts in the outlines of the objects **(top left)**, and starts to block in the background using paint diluted with water. He develops the outline in red **(top right)** and begins to block in areas of local colour **(centre**, **left** and **right)**. Local colour is the actual colour of the surface of an object without the influence of light, atmospheric conditions or nearby colours. The local colouring of the mug is red. He continues to fill in the background areas using flat, strong colours **(below)**.

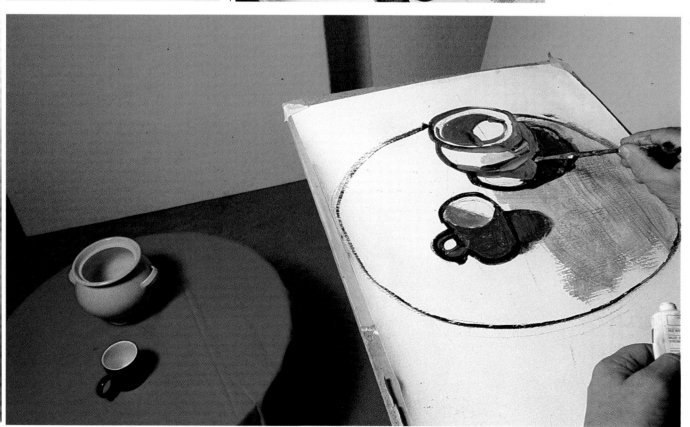

He treats the shadows as positive shapes, painting them in the same flat, opaque manner as the rest of the picture. He mixes the darkest tone on the pot from burnt umber and white **(below)**. *He allows the outlines to dominate the picture, developing the whole composition as a piece of design rather than as an observed still life* **(right)**. *Changing to a very large brush he puts in the large expanse of the table surface* **(bottom of page)**.

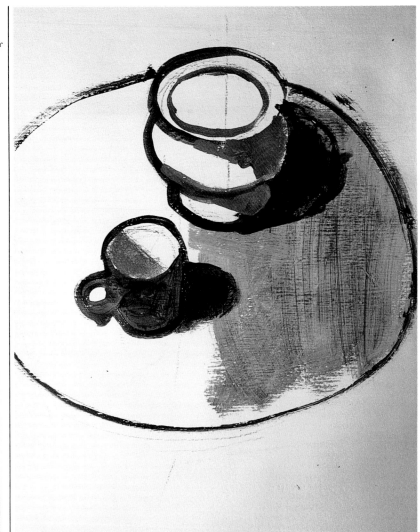

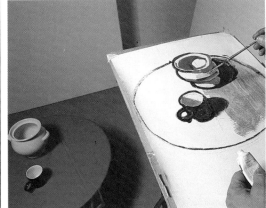

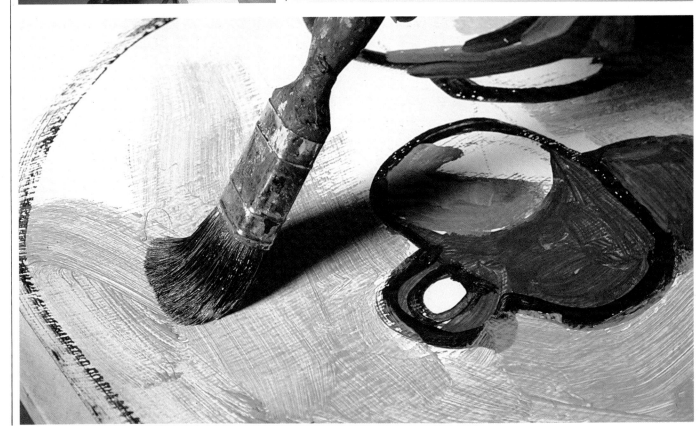

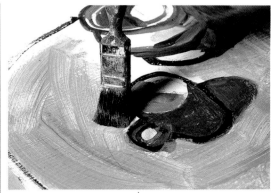

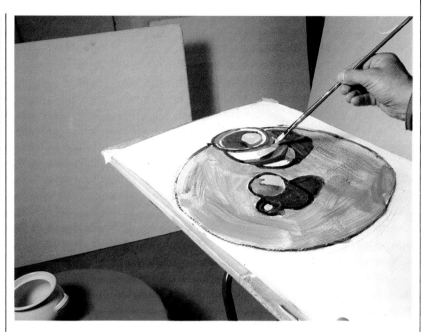

He takes the colour carefully up to the outline of the objects on the table, still maintaining the outlines as flat, unbroken areas of paint **(above)**.

At this stage the artist stands back from the composition, studying it in relation to his image, *looking for the underlying graphic qualities, changing or adding any shapes which may be necessary to improve the design of the painting* **(right)**.

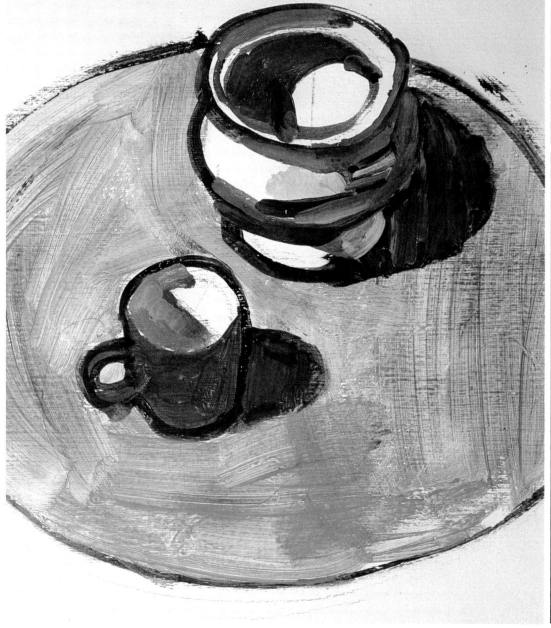

The painting so far is an arrangement of tones and colours, contained by the positive boundaries of the heavy outlines **(left)**. *From this stage onwards he does not use the still life objects for reference. Instead, he develops the painting by looking at the work and adding and changing the shapes and colours to improve the design.*
Areas which have become too dominant are broken up, and he works another colour into the shadows to give them more impact.

11

The addition of a solid black shape to the composition emphasizes the black lines in the picture **(above)**.

The artist fills in the remaining background spaces, using a colour which is echoed in the rest of the picture **(below left)**.

He works over the whole painting strengthening and lightening the tones and colours to add necessary contrasts and harmonies **(below** and **top left)**.

The artist keeps the colours fresh and immediate, and the final painting has a simple clarity which is a product of the simple geometric shapes and the clear, unfussy colour fields. The strong outlines separate the components, flattening the picture into a formal, organized arrangement of colour and tone.

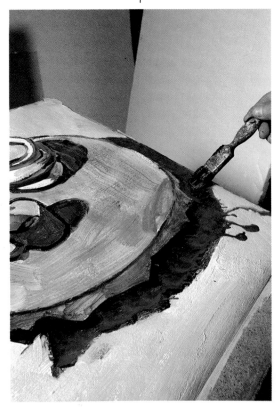

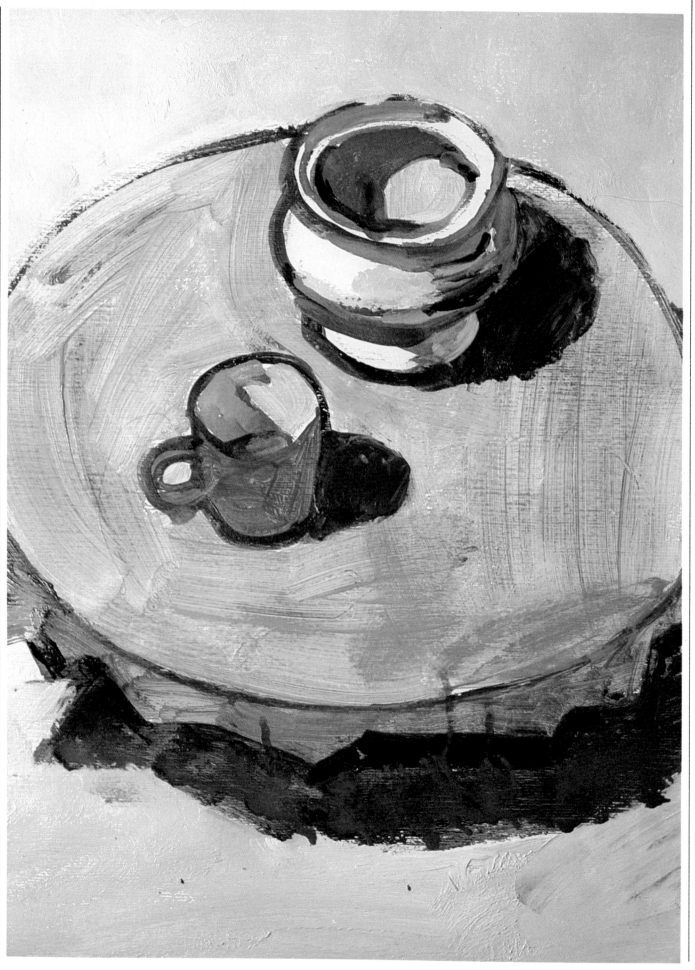

A TEASEL

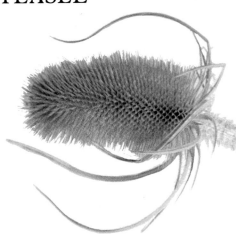

The artist sets out his palette of ochre, Naples yellow, white, cadmium yellow, burnt sienna and green. His support is a sheet of watercolour paper and onto this he smears ochre paint diluted with water using a large synthetic brush. He uses the handle of the brush (right) and a very small brush (opposite page, left) to draw out the spines of the teasel.

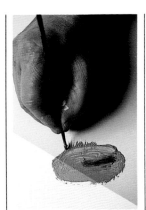

The subject of a still life does not have to be large or complicated. Even a single object can present the enquiring artist with stimulation and challenge. Here the artist has selected a single stem of dried teasel — the sort of object which you might overlook on a walk, or in your garden. But the eye of the artist is alert for material and sees subjects where the less visually aware eye of the non-artist would see only the background of everyday life. One of the contributions of the artist is to open our eyes, to make us look at the world around us with new eyes.

The artist was attracted by the strong geometric forms of the plant, the pale, slender, faceted stem, the oval of the prickly head and the graceful curves of the bracts which surround it. The head of the teasel provides the artist with plenty of opportunity to explore pattern and texture and the rich creams and ochres encourages him to use a limited palette.

The detail (below) shows the rich texture of the paint, the way the streaks allow the white of the support to show through and the way the paint holds the marks of the brush. Using a lighter mixture the artist then applies streaks, dashes and criss-crosses of colour.

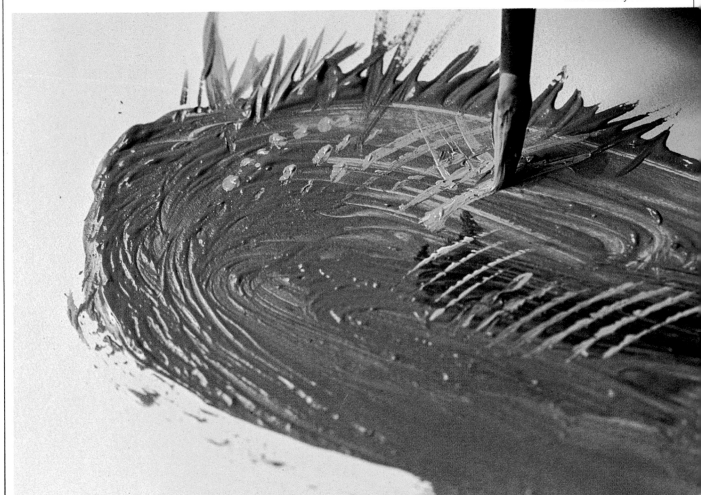

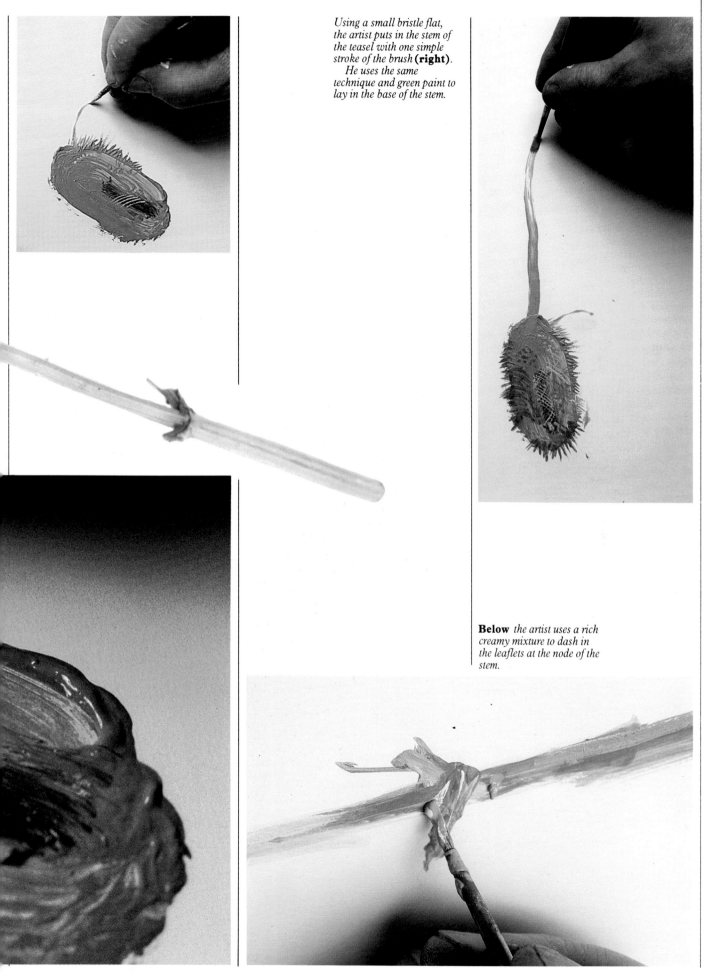

Using a small bristle flat, the artist puts in the stem of the teasel with one simple stroke of the brush **(right)**. He uses the same technique and green paint to lay in the base of the stem.

Below the artist uses a rich creamy mixture to dash in the leaflets at the node of the stem.

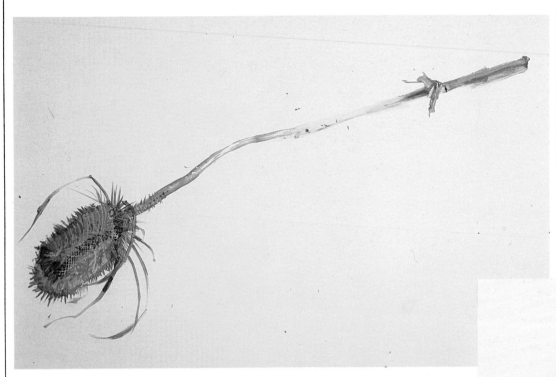

The artist continues to work into the head of the teasel. Using a fine brush and a deft calligraphic stroke he describes the whorl of bracts **(below)**.

The image emerges very quickly. Notice the way the artist has placed the plant on the diagonal of the picture area, bisecting it and creating two triangular background spaces **(left)**.

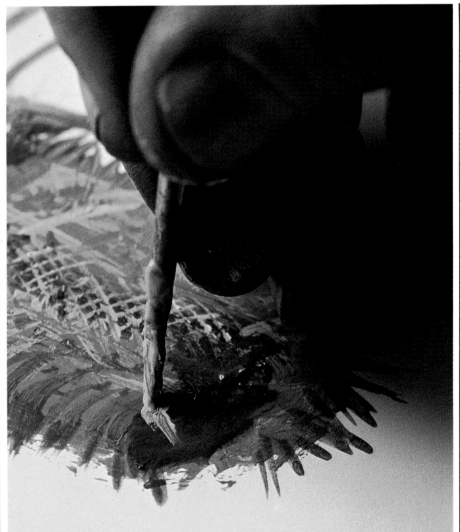

Acrylic paint is fast drying and the artist has to be quick if he wishes to work wet into wet. **Left** the artist develops the tonal contrasts, working wet over dry.

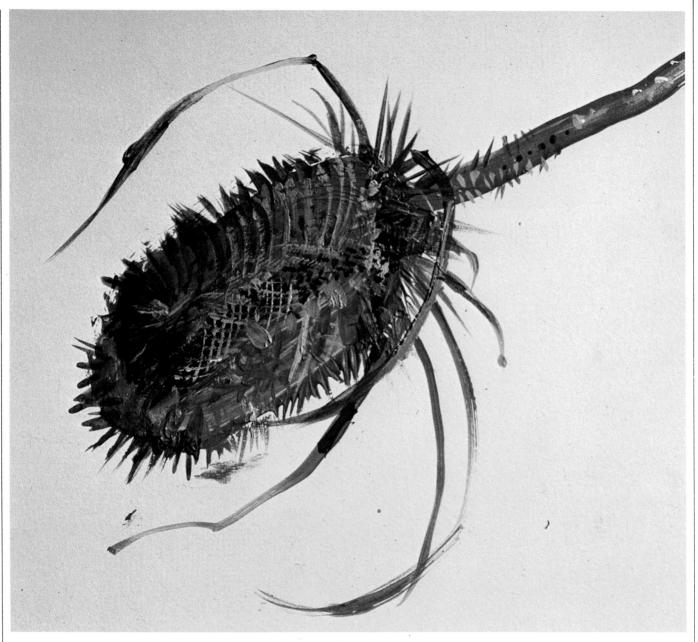

The detail (above) demonstrates the variety of marks and the surface richness that can be achieved using acrylic paint and a limited palette. In some areas the paint is thinly scumbled, in others it is thickly impasted. In a scumble the artist applies dry opaque paint so that the underlying paint layer, or the support, show through and contribute to the final colour effect. Impasted paint is applied thickly with a knife or a brush. The paint has been dragged, slurred, dabbed and stippled. The artist has used a selection of brushes and (left) uses a painting knife to lay in the shadow.

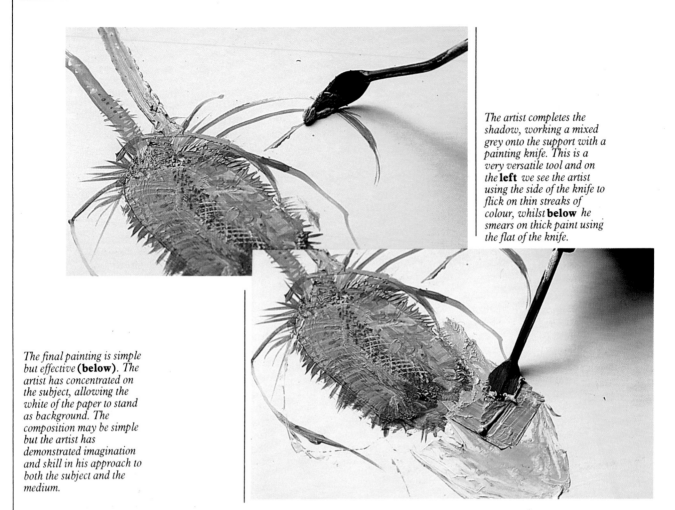

The artist completes the shadow, working a mixed grey onto the support with a painting knife. This is a very versatile tool and on the **left** we see the artist using the side of the knife to flick on thin streaks of colour, whilst **below** he smears on thick paint using the flat of the knife.

The final painting is simple but effective **(below)**. The artist has concentrated on the subject, allowing the white of the paper to stand as background. The composition may be simple but the artist has demonstrated imagination and skill in his approach to both the subject and the medium.

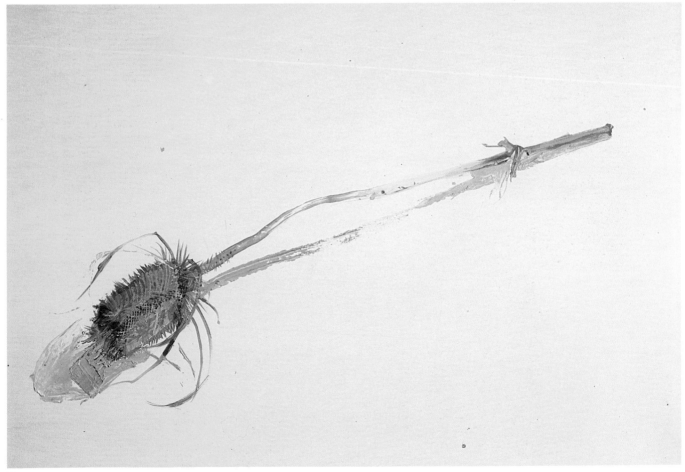

FREEING THE IMAGINATION

Surrealism has probably had more influence on twentieth century art than any other movement except Cubism. The Surrealists wanted to overcome the dominance of reason and conscious control and did so by methods designed to release primitive urges and imagery. They were influenced by Freud's theories of the unconscious and developed various 'automatic' techniques in order to breach the control of reason and release the submerged impulses and imagery. They believed that access to reality could only be gained through the unconscious mind. Automatism began with the 'automatic' drawing technique practised by Miro, Paul Klee and Andre Masson. The line of the pen or other instrument was allowed to move at will without any conscious planning. Masson tried to achieve the same result in painting by drawing a mass of lines in an adhesive substance on the canvas, adding colour by coatings of different coloured sands.

Decalomanie, one of these automatic techniques, is said to have been developed by Oscar Dominguez in about 1936 and was used afterwards by Max Ernst. Colour was splashed onto moderately thin white paper, with a broad brush. The wet sheet of paper was then covered with another sheet of paper and rubbed gently so that the pigment was transferred to the second sheet in a haphazard way. Two prints were produced in this way, and were thought to resemble fantastic grottoes or jungles or underwater growths and were given appropriately descriptive titles. The point of the process was that the painting was made without any pre-conceived idea of subject or form. Once an interesting image, form or texture had been achieved by such chance means it was often taken further and consciously developed or incorporated in another work.

The technique used here is frottage from the French frotter, to rub. The artist places a sheet of paper on a surface and rubs it with crayon or pencil so that the

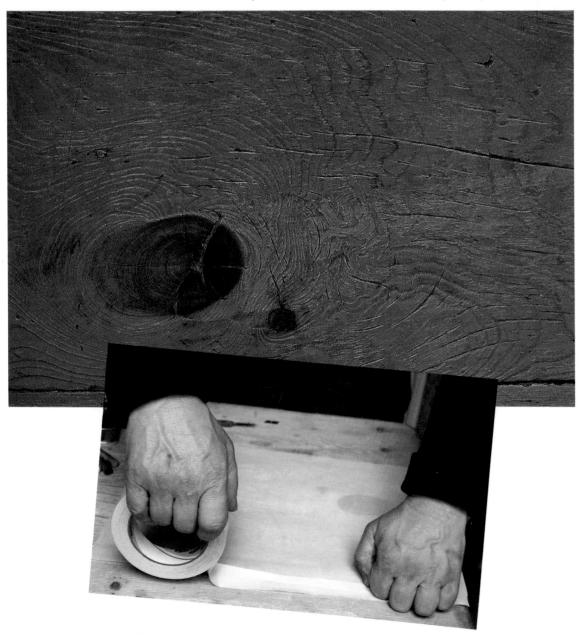

texture of the surface below is transferred to the paper. In a variation of this, grattage, a painted canvas is pressed down onto an uneven surface, such as a grid, and the paint is then scraped away to reveal a negative image of the texture beneath. Here the artist has used a frottaged texture as a background for a realistically described painting of a tomato — an interesting combination of abstract and realistic imagery.

You can try exercises such as this. They seem very simple but they are fun and you can learn a lot by doing them. They are especially useful if you feel that your painting is in a rut for you are forced to move away from your usual approach and techniques and to explore new ideas. You will also produce very attractive and exciting images.

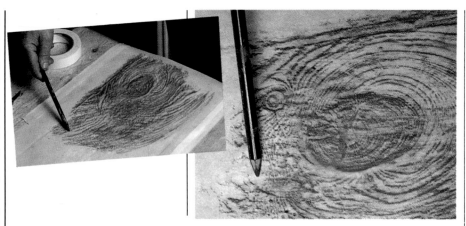

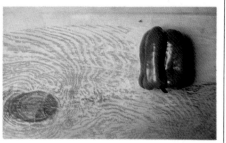

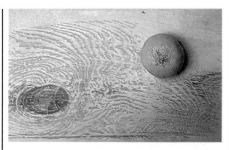

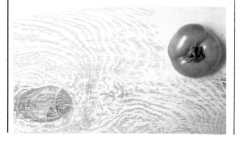

A great variety of patterns can be made from such textures as wood, fabric and other easily obtainable materials. The artist placed a sheet of paper over the required surface and drew into this in pencil or crayon, using smooth, even strokes (**top left**). *A more consistent pattern can be* obtained by using the side of the pencil lead (**top right**). *The texture of the surface emerges clearly on the paper* (**centre**). *It is worth experimenting with different media and colours* (**above**) *to discover other possible effects. When the artist has produced a satisfactory texture, he tries* to develop a simple still-life. *Using colourful fruit and vegetables, he explores the effect of various shapes and colours on the textured base* (**right**) *until he finds an interesting composition.*

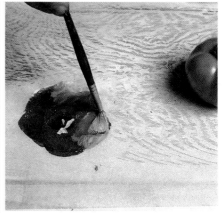

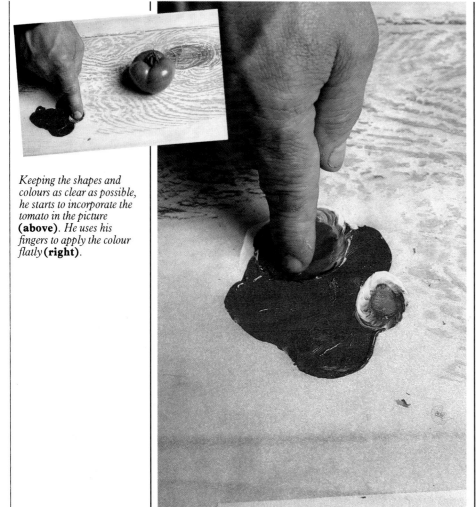

Keeping the shapes and colours as clear as possible, he starts to incorporate the tomato in the picture **(above)**. *He uses his fingers to apply the colour flatly* **(right)**.

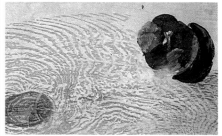

His intention is to produce a simple, graphic rendering rather than a realistic painting. Using a brush to obtain sharp, clear outlines **(top right)**, *he adds highlights and dark shadows* **(above)** *for dramatic effect. Finally he blots the wet paint* **(below)**, *to create extra interest.*

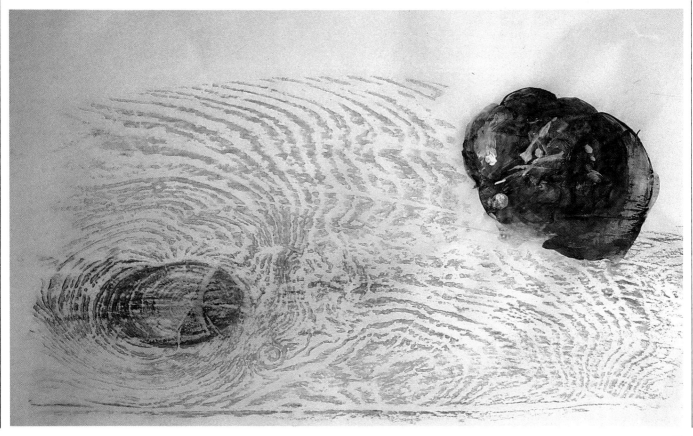

LOOKING FOR ABSTRACT PATTERNS

When you look for a subject to paint you are involved in a very complicated selection process, in fact, your painting actually starts long before you put pen to paper or brush to canvas, for by that stage you have already made several important decisions. You could not possibly include everything within your field of vision in your painting — you can only paint a small part of what you see. Many people select or 'frame' their subject by peering through a 'frame' made by their thumb and forefingers or their cupped hands. Others cut frames from card and peer through those.

Here we have suggested you choose quite a small object, a houseplant in this case, and start by choosing to paint a part of the subject, rather than the whole object. In this way you will be able to look at it as a pattern — and can forget what the object is. If the subject is patterned or textured exaggerate those features. You are not using the subject as the basis for an accurate botanical drawing, it is merely the starting off point from which to investigate shape, pattern and texture. It is also a useful way of forcing yourself to look at the subject very closely. You must put aside all you 'know' about the subject because you are seeing only a part of it so it is not 'explained'.

Once you have done this and have several paintings, you can make yourself two 'Ls' from light card and use them to make masks, moving the two pieces of card in and out so that you frame different details within a variety of shapes of frame.

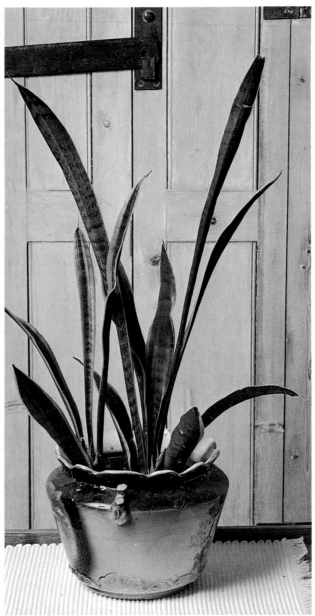

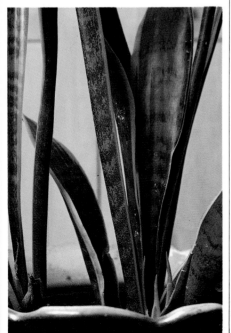

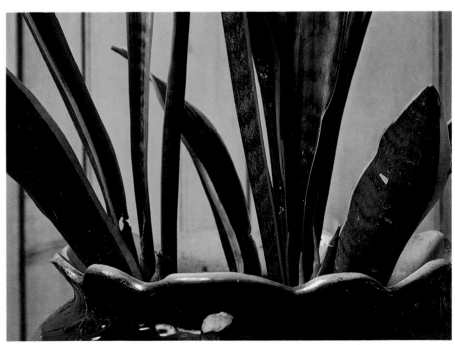

*The potted plant (**left**), though simple in itself, offered the artist a range of shapes and patterns. By studying the subject carefully and looking at small sections rather than at the whole the artist tries to see the subject in a new way (**below**). Exercises such as this are very refreshing and for the artist the ability to see beyond the obvious is very important.*

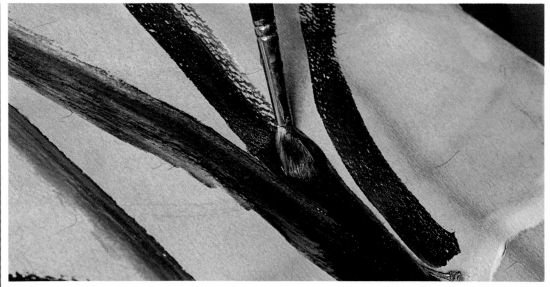

The artist decided to work with acrylic because the paint is flexible and dries quickly allowing him to develop several images within a very short time. His support is heavy watercolour paper. He starts by making a free painting of the whole subject using a large brush **(above)** for the main parts of the painting and a small flat for more detailed areas **(top right)**. He works boldly, painting the large shapes with sweeping brush strokes so as to simplify the image **(right)**. He continues to build up the picture in this freehand, flowing way, making the most of shapes, colours and patterns which contribute to the abstract quality of the picture **(bottom left)**. He keeps the colours flat and dramatic in these first stages **(below right)**.

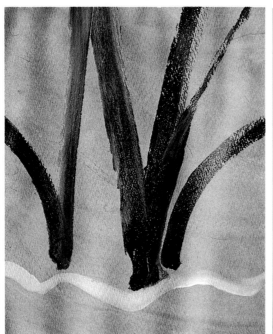

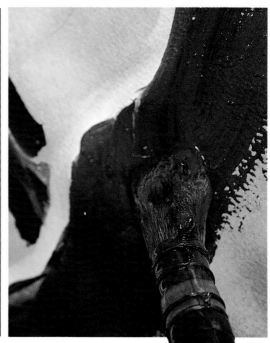

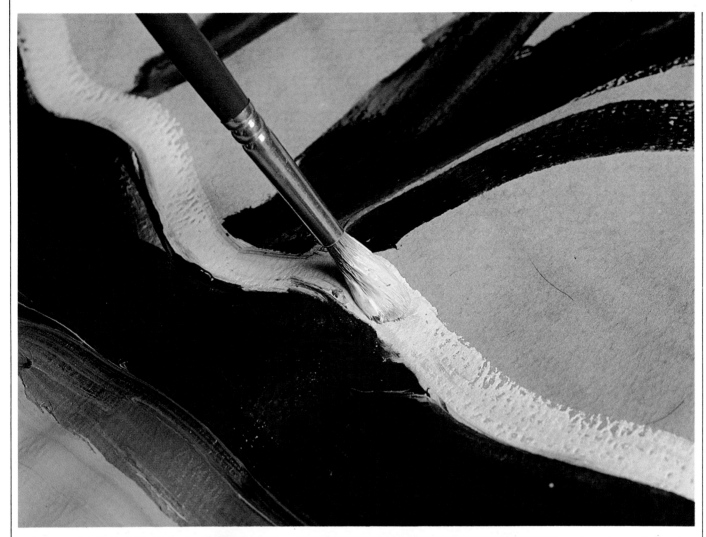

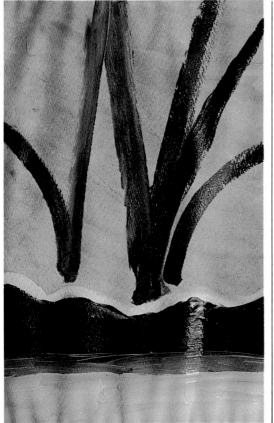

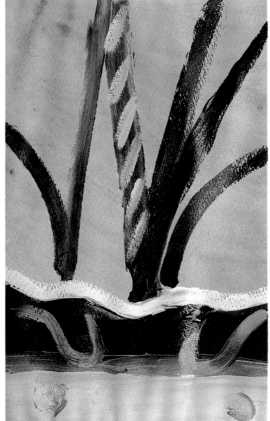

He emphasizes lines and shapes by using pure colour directly from the tube. **Above** thick white paint is scrumbled on freely, the texture of the paper allowing the ochre underpainting to show through the pure white paint. At this stage the artist is allowing the flat shapes to dictate the composition of the painting. He avoids the temptation to develop the tonal qualities of the painting and concentrates on the pattern-making aspects of the subject **(bottom left)**. He embellishes the picture by adding decorate details and does not concern himself with achieving a realistic image **(bottom right)**.

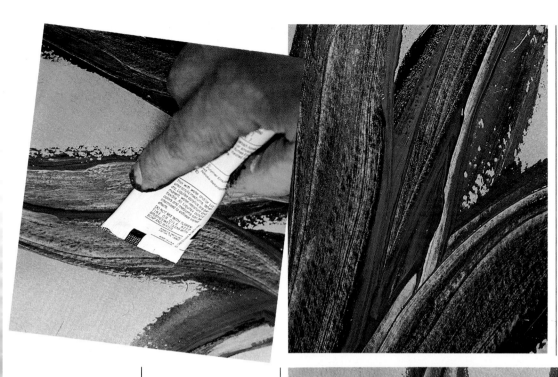

The artist works into the wet paint creating sgrafitto textures with any tool to hand. **Far left** he uses the bottom of the paint tube to create striations in the paint. The more effects you see the more interesting the painting will look, and the more interesting the compositions within the whole will be. The end of his paintbrush was used to make veins and ridges **(left)**.

At regular intervals the artist stands back from the picture and assesses its progress as an abstract composition **(below left)**. Forgetting the subject from which it was painted, he thinks of ways in which he can improve the painting. He strengthens the colour and tone, adding detail as necessary **(below right)**.

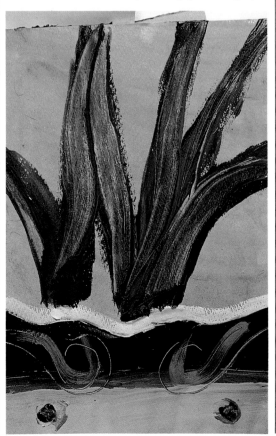

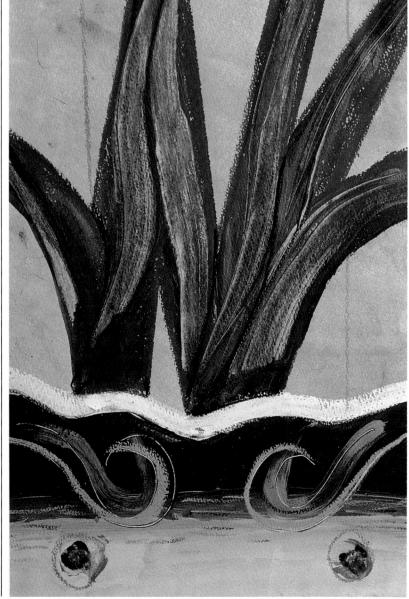

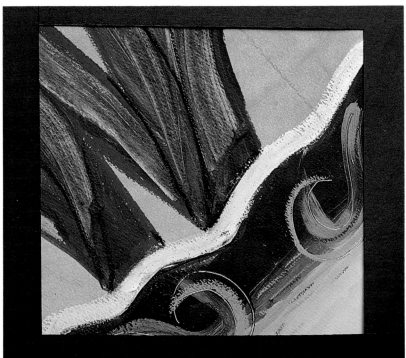

Now the artist looks again at the composition, seeking all the pictures-within-the-picture that he can find. To do this he makes a frame from two L-shaped pieces of card **(top left)**. *These can be combined to make a square or rectangular frame of any size or proportion* **(left)**. *By arranging the frame in different positions on the canvas, it is possible to explore the compositional possibilities of the subject. He does not stick to vertical and horizontal arrangements* **(below)** *but also considers those based on diagonals* **(above)** *which remove the image even further from what we expect to see and thus emphasize the abstract qualities.*

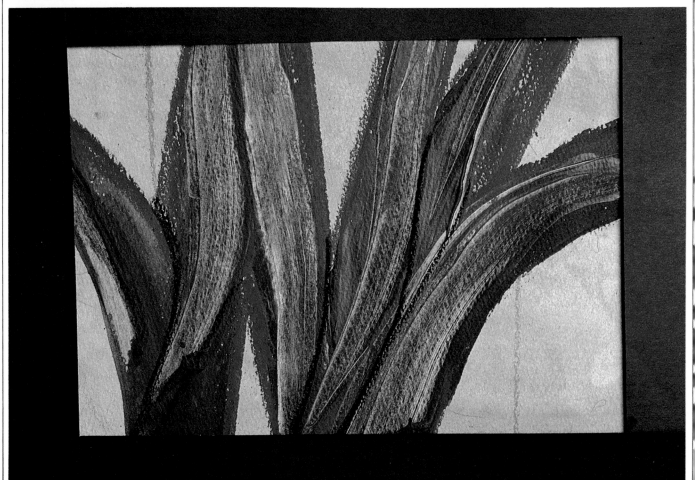

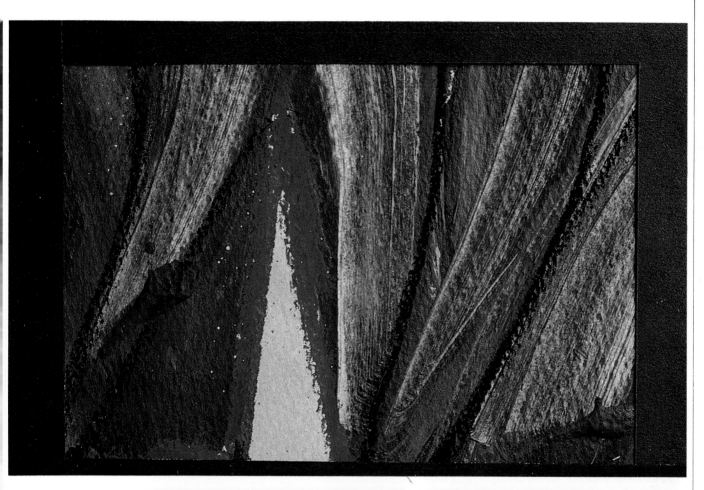

Here the artist has masked the painting in such a way that the image is lost on the canvas, the isolated patterns are not recognizable as objects or parts of an object **(above)**. *By moving the frames very slightly, he instantly changes the picture into something quite different* **(below left** *and* **right)**. *By developing an awareness of the possibilities and limitations of compositions you will increase your ability to select an interesting view or angle from any subject or situation.*

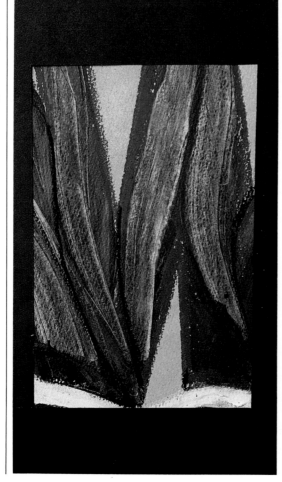

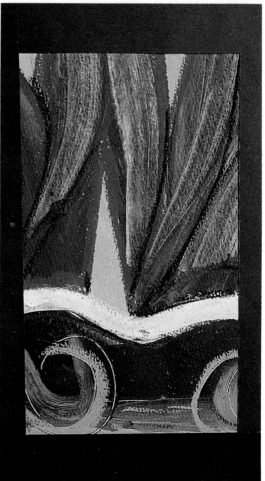

VEGETABLES WITH BOTTLE

Artists are divided in their reactions to acrylic paint which is still, after all, a fairly new medium only introduced to their repertoire early this century. You should not be afraid to experiment with it for it has many advantages and artists like David Hockney use almost nothing else. It is flexible, quick-drying and relatively clean to use. It requires decisiveness or you will find that your paint has dried, and can only be changed by overpainting.

Acrylic is not a substitute for oil or the waterbased paints although it can be used to create many of the same effects. So if you want to use and investigate acrylic you should approach it as a medium in its own right rather than as a substitute for other more established mediums.

Here the artist chose to use acrylic because he felt that its pure bright colour, opacity and covering power, and all cleaness of its lines were particularly suited

to the bold colour scheme and pattern of the subject.

The composition was based on a classic triangle with the neck of the bottle at the apex and the focal point. The objects have been carefully selected to provide a variety of textures, colour, shapes and sizes in order to create a stimulating study and an exciting finished painting.

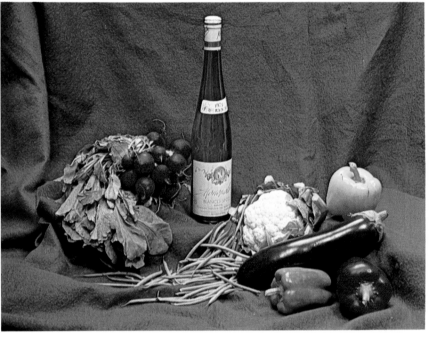

The artist has selected brightly coloured objects, with a strong emphasis on complementary colour (above). He has arranged them in such a way so as to maximize the effect of colour, shape and textures, using the tall bottle as a focal point.

Using stretched watercolour paper, the artist blocks in the broad outlines of the subject using raw and burnt sienna, red and orange (above).

He uses Hooker's green and phthalo green, varying the tones by adding white (below). At this stage he is interested in recording the position of the objects and their general colours.

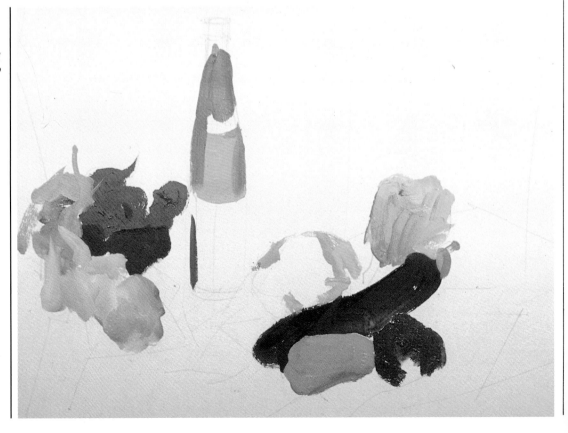

Pure white paint is used to describe the areas where a highlight and a light local colour coincide, on the label of the bottle and on the florets of the cauliflower **(left)**.

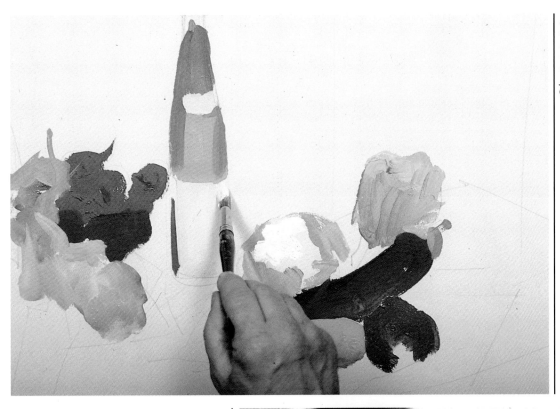

The artist uses thick, creamy paint for most of the painting **(below)**, *adding water only when a thin wash or glaze is required. He adds matt or gloss medium to vary the surface of the dried paint. Using a large synthetic brush the artist lays in the larger elements of the composition, using directional brushstrokes which follow form* **(right)**.

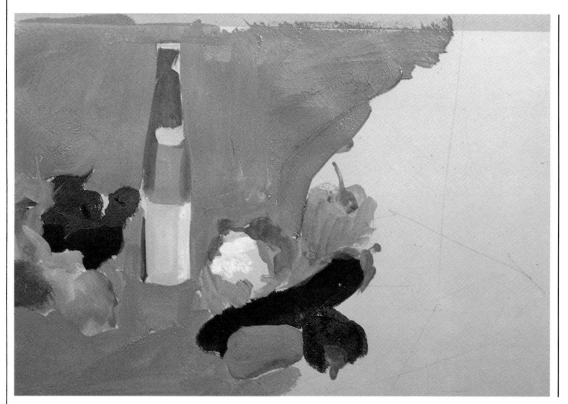

The artist mixes a large quantity of phthalo green with white paint, and then blocks in the background using a large brush and flat, unmodulated brushstrokes **(left)**.

He continues to work into the background, adding a small amount of yellow to the mixture to vary the tone. Keeping the paint fairly wet he uses Hooker's green to block in the darker tones of the background — the shadows on the fabric **(right)**.

Using a mixture of Hooker's green and burnt sienna the artist establishes the darker tones in the foreground **(below)**.

He develops the tonal contrasts on the vegetables, using darker and lighter shades of the local colour **(above)**.

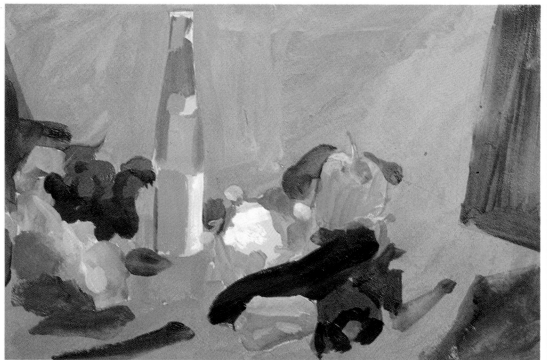

A great variety of patterns can be made from such textures as wood, fabric and other easily obtainable materials. The artist placed a sheet of paper over the required surface and drew into this in pencil or crayon, using smooth, even strokes **(top left)**. A more consistent pattern can be obtained by using the side of the pencil lead **(top right)**. The texture of the surface emerges clearly on the paper **(centre)**. It is worth experimenting with different media and colours **(above)** to discover other possible effects. When the artist has produced a satisfactory texture, he tries to develop a simple still-life. Using colourful fruit and vegetables, he explores the effect of various shapes and colours on the textured base **(right)** until he finds an interesting composition.

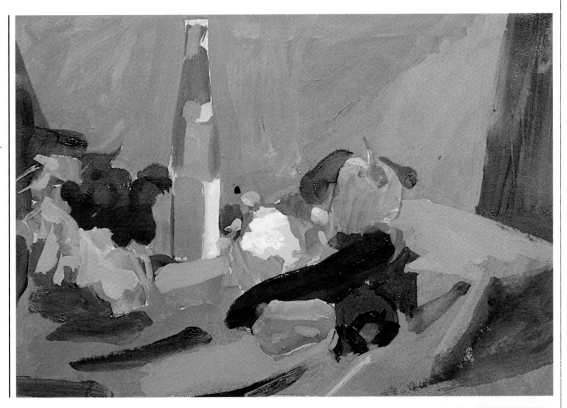

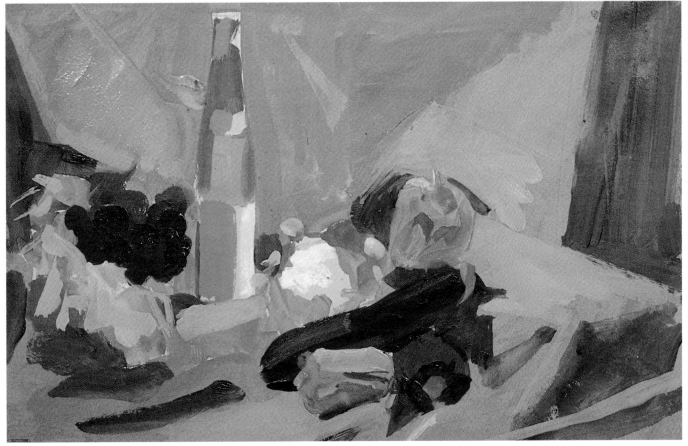

Keeping the shapes and colours as clear as possible, he starts to incorporate the tomato in the picture **(above)**. He uses his fingers to apply the colour flatly **(right)**.

His intention is to produce a simple, graphic rendering rather than a realistic painting. Using a brush to obtain sharp, clear outlines **(top right)**, he adds highlights and dark shadows **(above)** for dramatic effect. Finally he blots the wet paint **(below)**, to create extra interest.

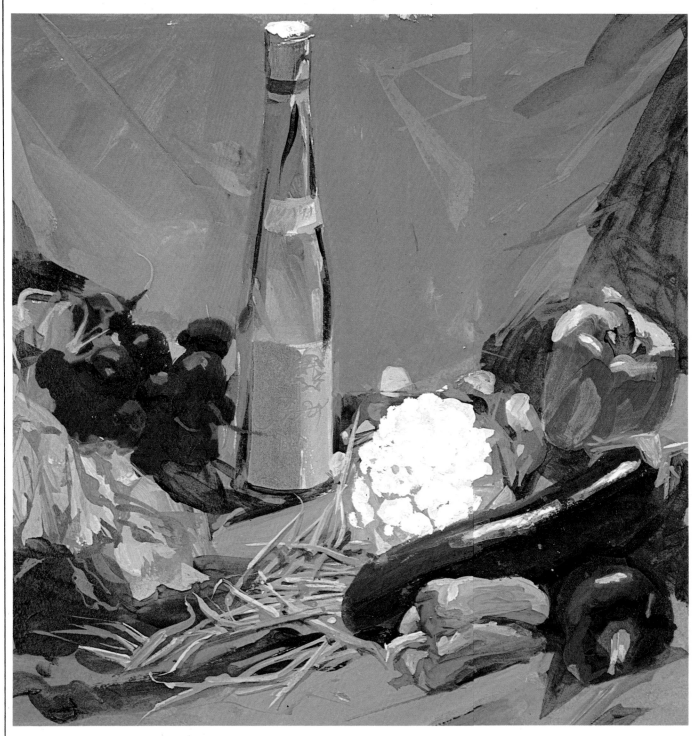

The artist continues to develop the painting in this way, constantly returning to the subject to check the colour relationships. Inevitably, the light conditions change, no matter how well controlled, and this affects the way in which the subject is perceived. The artist constantly adjusts his colours, matching them by eye, remembering that they will be affected by the surrounding colours.

The finished picture **(above)** shows the bold brilliance of the medium, and demonstrates how well acrylic describes subjects which require this bold treatment.